D1302104

BP PORTRAIT AWARD 2012

National Portrait Gallery

Published in Great Britain by
National Portrait Gallery Publications
National Portrait Gallery
St Martin's Place, London WC2H 0HE

Published to accompany the BP Portrait
Award 2012, held at the National Portrait
Gallery, London, from 21 June to
23 September 2012, the Scottish
National Portrait Gallery, Edinburgh from
3 November 2012 to 27 January 2013 and
the Royal Albert Memorial Museum, Exeter
from 9 February 2013 to 19 May 2013.

For a complete catalogue of current
publications please write to the address
above, or visit our website at
www.npg.org.uk/publications

ISBN 978 1 85514 456 9

A catalogue record for this book is
available from the British Library.

10 9 8 7 6 5 4 3 2 1

Managing Editor: Christopher Tinker
Project Editor: Kate Tolley
Design: Anne Sørensen
Production: Ruth Müller-Wirth
Photography: Prudence Cuming
Printed and bound in Italy
Cover: *Rosie and Pumpkin* by
Vanessa Lubach

premier partner of the London 2012 Festival

FSC
www.fsc.org
MIX
Paper from
responsible sources
FSC® C016114

CONTENTS

DIRECTOR'S FOREWORD

Each year the search for portrait paintings that can astonish with their virtuosity is balanced with the desire to find those that demonstrate real human insight and empathy. The demands on a portrait painter – whatever their stylistic approach – to give viewers the chance to be introduced to a real person, who the artist studied over many hours, are very great. It is a tough challenge, but one that is responded to magnificently in the entries to the BP Portrait Award each year.

Portrait painting is thriving in the UK. Given the number of overseas entries (from seventy-four countries), it is appropriate that in a special Olympic year there appears to be growing international engagement, encouraging the particular skill of painting people. Australia, the United States and the Scandinavian countries each have successful contemporary portrait competitions. However, while working on the consistent basis of judging the works anonymously and from the actual paintings, the BP Portrait Award grows in strength as it gains more diverse entrants.

2012 is the third year of the BP Portrait Award: Next Generation project, developed as part of the Cultural Olympiad. Talented young people have been given the chance to work with prizewinners, and some of that work will be exhibited as part of the display for this Olympic year. The focus and concentration from those taking part is very impressive, and I am grateful to those artists who have given their time to be part of this programme – this extended interest in contemporary painted portraiture is important for the future.

The sponsorship by BP for the competition, exhibition and Travel Award over twenty-three years is an exceptional arts partnership, and I am delighted that BP announced in January 2012 that this would develop over another five-year period from 2013. My thanks, as ever, go to Des Violaris, Ian Adam, Peter Mather and other colleagues at BP, as well as to Bob Dudley, Group Chief Executive.

Sandy Nairne
Director, National Portrait Gallery

SPONSOR'S FOREWORD

The National Portrait Gallery houses the world's largest collection of portraits, from the sixteenth century to the present day. For the past twenty-three years, BP has been pleased to partner with the Gallery in support of its annual Portrait Award, designed to connect people and to inspire creativity. Recently BP announced a further commitment to the Gallery, and in particular to the Portrait Award, for a further five years.

2012 has been another great year in further extending the awareness and reach of this internationally respected competition, with 2,187 entries from seventy-four countries across the globe, compared to sixty-five countries last year. The artists' enthusiasm and aptitude to produce extraordinary work has made the BP Portrait Award one of the world's most prestigious art prizes. The competition culminates in an exciting public exhibition of the works, including those by artists shortlisted for prizes.

In this Olympic year, the BP Portrait Award: Next Generation project, a series of workshops to inspire fourteen to nineteen year olds in the art of portraiture, will travel to venues around the country, engaging with over 400 budding young artists. The growing popularity of the exhibition is evident in the visitor numbers year on year. In 2011, the exhibition attracted over 320,000 people, a testament both to the quality of the paintings and also to the dedication of Sandy Nairne, Pim Baxter and their team in delivering this world-class programme.

My thanks go to all the artists who submitted work from across the globe, the judges and the exceptional people at the National Portrait Gallery who provide an opportunity for so many artists to exhibit their work in an internationally renowned gallery, launching many careers.

Congratulations to the winning artists for their inspirational pieces of work.

Bob Dudley
Group Chief Executive, BP

Reflection

Michael Rosen
Poet and Children's Laureate, 2007–9

I first came face to face with portrait painting when my best friend at school decided he would go to art school. At the age of about fifteen he put himself through a tough self-taught apprenticeship of drawing and painting, going to exhibitions, reading the biographies and diaries of painters and listening to jazz. Almost all our time together was taken up with him either doing this stuff or talking about it, and a good deal of it was taken up with drawing and painting self-portraits. He kept experimenting with paints and surfaces: many different kinds of paper and card, wood and cloth. He used oils, but he also started mixing glue into household paint or school powder paint.

I can now see some fifty years later that this energy and diversity, focused in on what was often a lonely exploration of himself, put me in awe. I wanted to have inside me that inner thing that was driving him, so that it could drive me somewhere. Of the drawings and paintings themselves, I was never quite sure. He kept saying they were rubbish, but it just made him want to do more. I went on looking and wondering until one time I went over to his house in suburban north London and he showed me an oil painting he had done. Again, it was of himself, but he hadn't done it from life, he said. He had been coming home on the Tube at night,

looked up and seen his reflection in the window. He said he had remembered it, dashed in, got out a bit of hardboard and put the oil on in great thick splurges. When I looked at it, I was stunned. In my eyes, he had captured in these swirls the shadow of introspection that often crossed his face, the slightly spoiled puffiness of his cheeks, the self-conscious artiness in the way he carried his head and neck – it was all there. And yet it wasn't a likeness. How had he done that? It seemed like magic. He had captured a state of mind, a sense of moment in a life in these thick blobs of oil. In the thickness of it, he had even caught the odd angle of his eyebrows when he talked earnestly about Van Gogh or Charlie Parker.

I remember saying to him that I thought it was brilliant and so he gave it to me. I've kept it with me all my life. I've propped it up on top of books, on windowsills, up against pillars. We stopped seeing each other some forty years ago, I think. We both know where we are. He is much taken up with philosophy and Sanskrit culture. He didn't stick with painting, even though there was a strong presence of it in his family with his cousin being a celebrated international artist. But I have this painting, which I think expresses a person, a time, a state of being, a thought, a longing. Very nearly every time I'm on the Tube and I see my

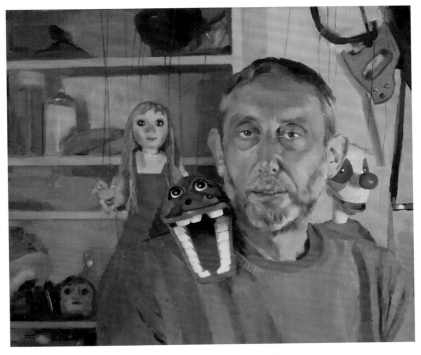

Michael Rosen, Patron of the Little Angel Theatre, London by Lee Fether, 2011
Oil on linen, 625 x 720mm (24⁵/₈ x 28³/₈")

reflection in the window opposite, I think of the painting and I think of him and I think of the creative passion of those times. In fact, I stole some of that in my own work – and still do. But something else: it took me to looking at the painting of faces, portraits and self-portraits.

In what was at the time slightly irritating, he would often do that thing of leading you to someone well known but then either discovering a work that no one else had ever mentioned or saying: if you think he's great, have you ever heard of so-and-so? This is what he did with Augustus John. John was on his last legs but enjoying a reputation that teenage boys like us wanted to be part of. I seem to remember that there was a BBC arts programme about him that was appropriately scandalous. My friend could cap it: never mind him, it's his sister's stuff you want to look at. At the time, I didn't know why he said that. All I know now is that whenever I come across a Gwen John painting I have a strong sense that this is someone I once knew, a woman who was sadder than she wanted to be.

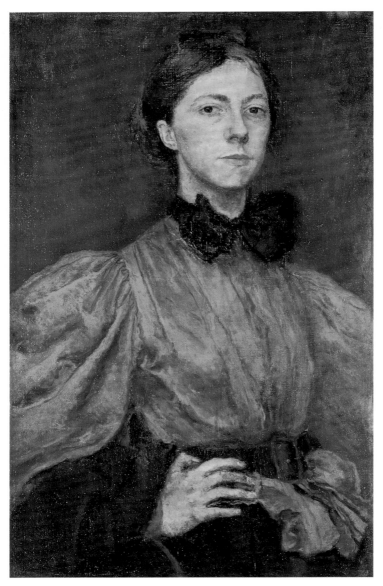

Self-portrait by Gwen John (1876–1939), c.1900 (NPG 4439)
Oil on canvas, 610 x 378mm (24 x 14⁷/₈")

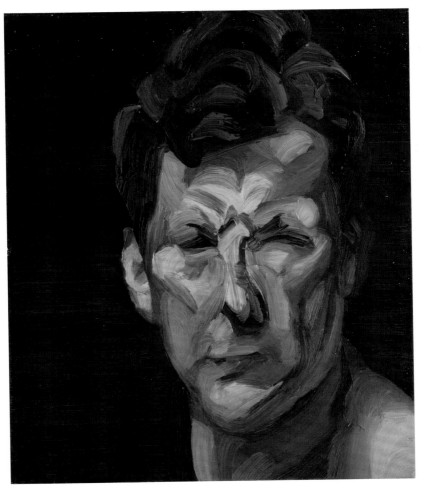

Self-portrait by Lucian Freud (1922–2011), 1963 (NPG 5205)
Oil on canvas, 305 x 251mm (12 x 9⁷/₈")

In English, we put many seemingly inconsequential words in front of nouns – 'the', 'a', 'some', 'any' – but they all mean a lot, and even the lack of any word has a meaning. As a game, I sometimes try standing in front of a portrait and ask: is the unsaid title of this painting 'The Woman' or 'A Woman', 'My Woman', 'Her Own Woman', 'Woman', 'Some Woman', 'Any Woman', 'That Woman' … or what? Of course, it could be several at the same time. Isn't there a way of looking at Lucian Freud's pictures of himself in which we might say that the title is 'My Own Man'

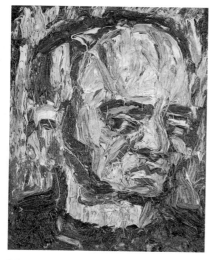

Self-portrait by Leon Kossoff (b. 1926), 1981 (NPG 5772)
Oil on board, 424 x 330mm (16³/₄ x 13")

and 'Man'? One way to reach those general truths and thoughts about our humanity is through the most detailed, specific exploration of one individual, it seems. My friend stood me in front of Freud's paintings at an exhibition in the early 1960s, then in front of a painting by his cousin, Leon Kossoff, whose work was included in the same show, and said that he wanted to paint like that.

In the end, it wasn't the route he wanted to take, but a few years later another friend, similar in some ways to the first – full of esoteric enthusiasms – said that he knew a great artist who not enough other people thought was great: Anthony Green. I agreed. Looking at them now, I think that what Green does with the pictures of himself embedded in his past and present seem oddly close to how I have put my friend's Tube train self-portrait into my memory and daily life: portraits in lived-in rooms – or is it, rooms with lived-in portraits?

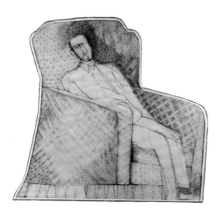

Self-portrait in Father's Chair by Anthony Green
(b. 1939), 1967 (NPG 6106)
Pencil, 865 x 842mm (34¹/₈ x 33¹/₈")

BP PORTRAIT AWARD 2012

The Portrait Award, in its thirty-third year at the National Portrait Gallery and its twenty-third year of sponsorship by BP, is an annual event aimed at encouraging young artists to focus on and develop the theme of portraiture in their work. The competition is open to everyone aged eighteen and over, in recognition of the outstanding and innovative work currently being produced by artists of all ages working in portraiture.

THE JUDGES

Chair: Sandy Nairne,
Director,
National Portrait Gallery

Dr Augustus Casely-Hayford,
Curator and Cultural Historian

Sarah Howgate,
Contemporary Curator,
National Portrait Gallery

Martin Jennings,
Sculptor

Nicola Kalinsky,
Interim Director,
Scottish National Portrait Gallery

Des Violaris,
Director UK Arts & Culture, BP

THE PRIZES
The BP Portrait Awards are:

First Prize
£25,000, plus at the Gallery's discretion a commission worth £4,000.
Aleah Chapin

Second Prize
£8,000
Ignacio Estudillo

Third Prize
£6,000
Alan Coulson

BP Young Artist Award
£5,000
Jamie Routley

PRIZEWINNING
PORTRAITS

First Prize

Auntie
Aleah Chapin

Oil on canvas,
1470 x 965mm (57$^{7}/_{8}$ x 38")

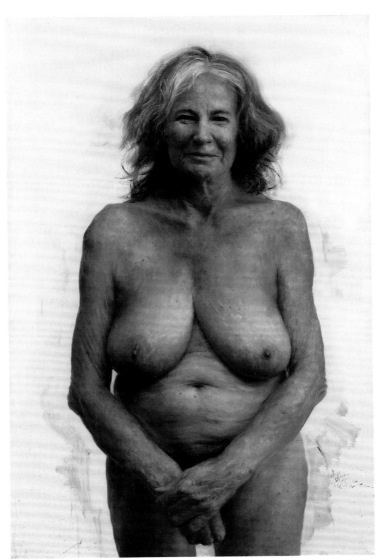

El abuelo (Agustin Estudillo)
Ignacio Estudillo

Oil on canvas,
2000 x 2000mm (78³/₄ x 78³/₄")

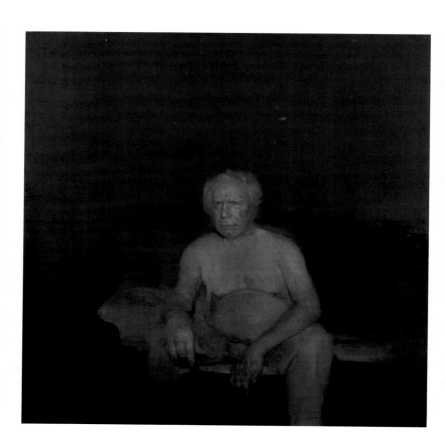

Richie Culver
Alan Coulson

Oil on wooden board,
850 x 590mm (33^1/$_2$ x 23^1/$_4$")

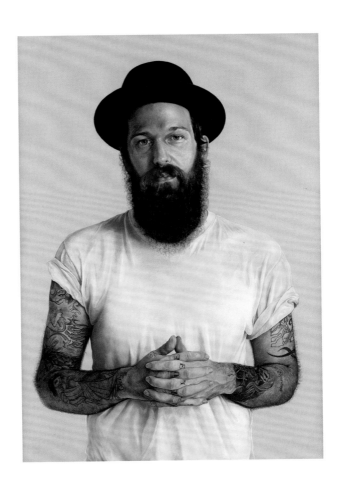

Tony Lewis
Jamie Routley

Oil on canvas,
405 x 355mm (16 x 14") each

SELECTED
PORTRAITS

Pasha Triptych
Ismail Acar

Oil on canvas,
1250 x 800mm (49$\frac{1}{4}$ x 31$\frac{1}{2}$")

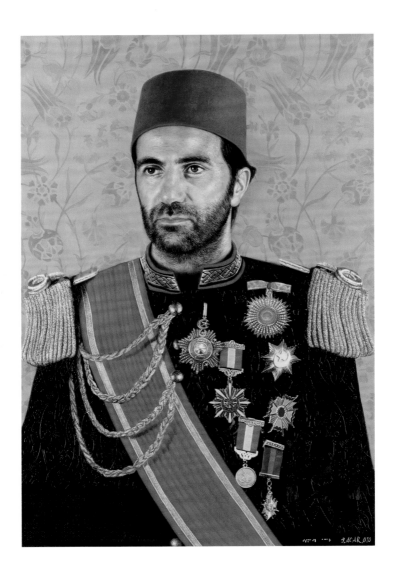

Rob Fahey on Court
Rupert Alexander

Oil on canvas,
950 x 690mm (37³/₈ x 27")

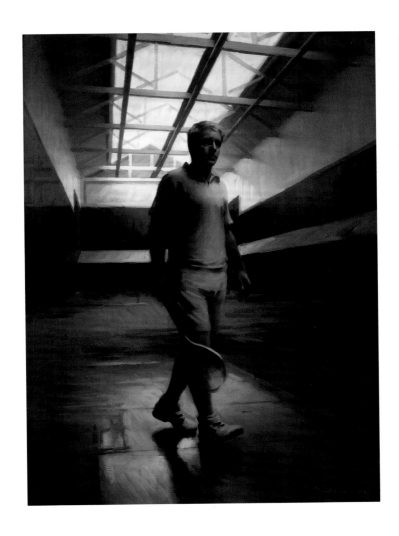

Jonathan Ansell
Mary Jane Ansell

Oil on wooden panel.
315 x 342mm (12$^1/_2$ x 13$^1/_2$")

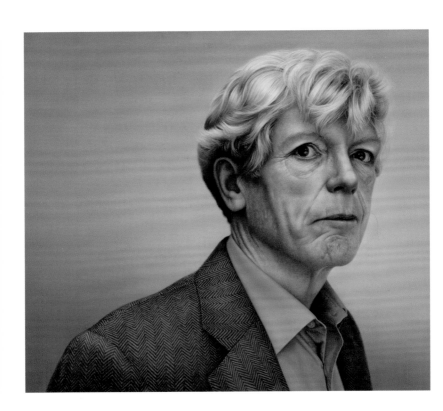

Lindsay Lohan
Ben Ashton

Oil on panel,
290 x 200mm (11 $^3/_8$ x 7 $^7/_8$")

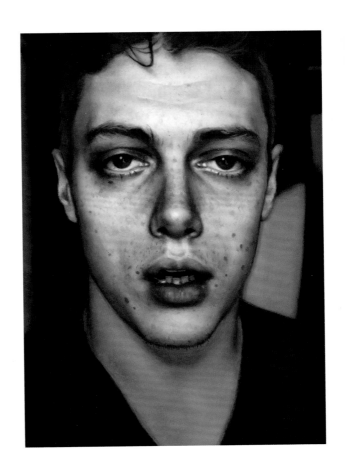

Still Waiting
Antonio Barahona

Oil on canvas,
800 x 600mm (31$\frac{1}{2}$ x 23$\frac{5}{8}$")

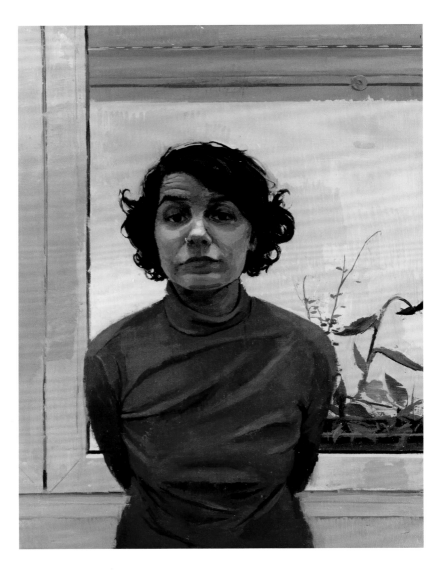

Bruised
Nathalie Beauvillain Scott

Oil on canvas,
610 x 610mm (24 x 24")

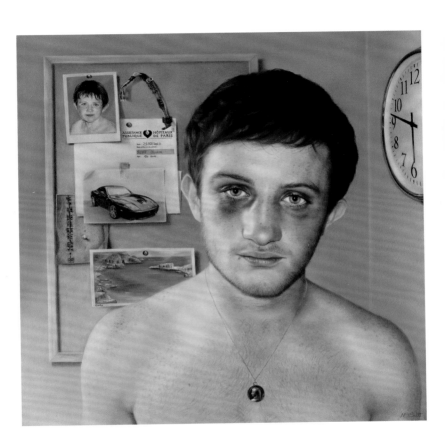

The Postman
Frances Bell

Oil on linen,
900 x 750mm (35 3/8 x 29 1/2")

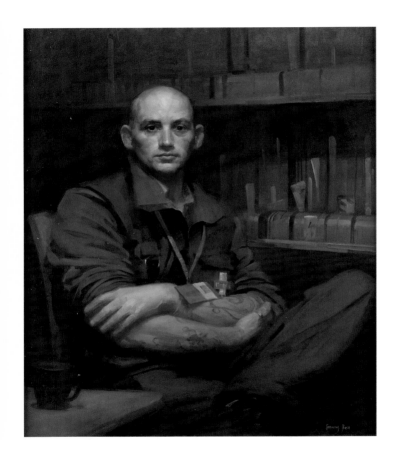

92 Years
Tim Benson

Oil on canvas,
1200 x 1220mm (47$^{1}/_{4}$ x 48")

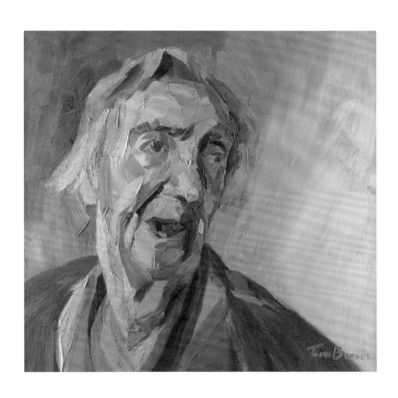

The Spoken Truth
Szekely Bogdan

Oil on panel,
290 x 210mm (11³/₈ x 8¹/₄")

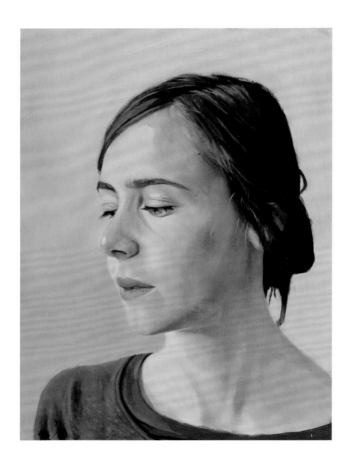

What I See in Her
(Quello che vedo in lei)
Gianluca Capaldo

Oil on canvas,
490 x 1109mm (19$^1/_4$ x 43$^5/_8$")

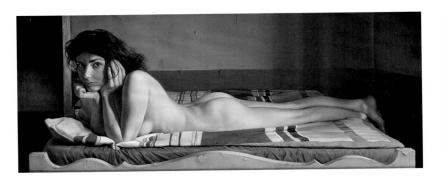

Today You Were Far Away
Ian Cumberland

Oil on linen,
1500 x 1000mm (59 x 39$^{3}/_{8}$")

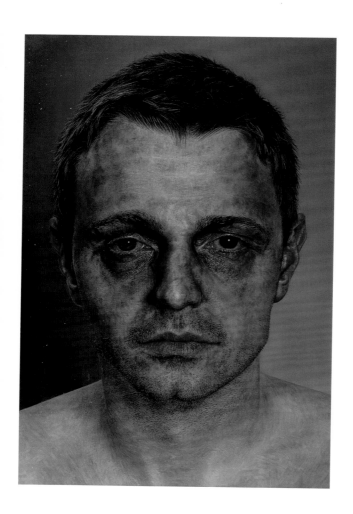

The Dialects Of Silence
(Portrait of Michael Longley)
Colin Davidson

Oil on linen,
1270 x 1270mm (50 x 50")

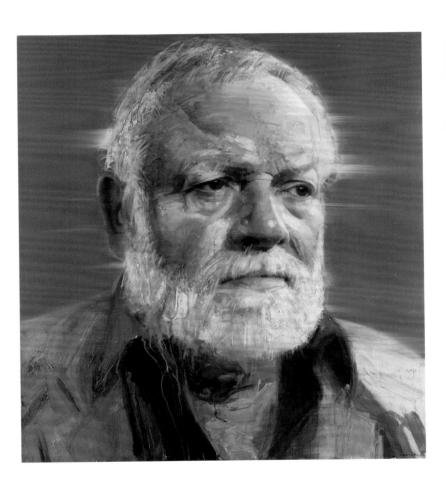

Tim
Tom Dewhurst

Oil on canvas,
1000 x 790mm (39$^{3}/_{8}$ x 31$^{1}/_{8}$")

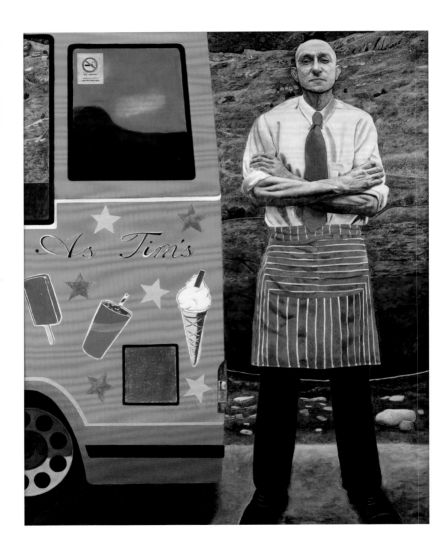

Devan ATMYS
David Eichenberg

Oil on wooden board,
260 x 220mm (10$^{1}/_{4}$ x 8$^{5}/_{8}$")

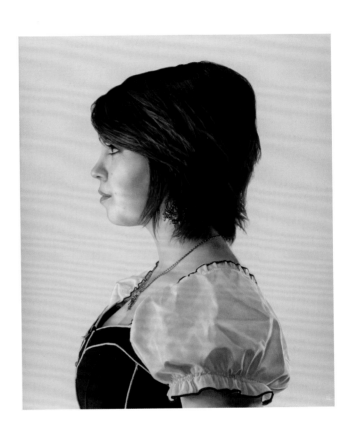

John Godfrey CBE,
2010 High Sheriff
Miriam Escofet

Oil on canvas on panel,
700 x 500mm (27$\frac{1}{2}$ x 19$\frac{3}{4}$")

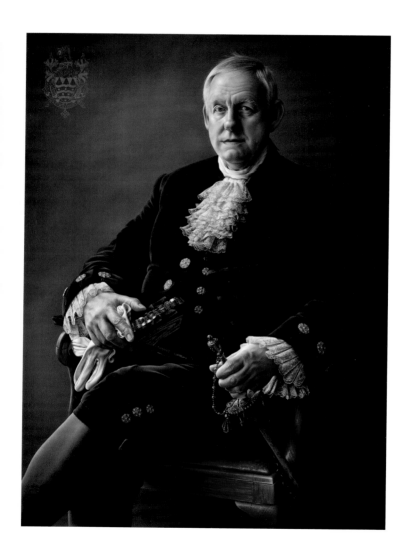

The Portrait Painter
Nancy Fletcher

Oil on wooden board,
395 x 320mm (15$^{1}/_{2}$ x 12$^{5}/_{8}$")

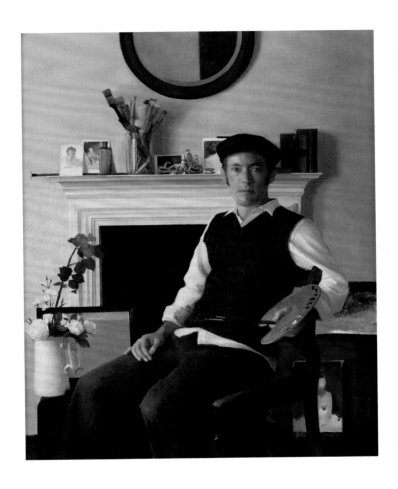

Joachim
Nathan Ford

Oil on canvas,
280 x 200mm (11 x 7$^{7}/_{8}$")

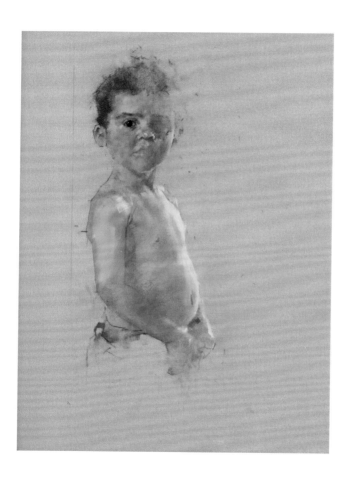

Le (Salmacis Num. 3)
Ivan Franco Fraga

Oil on canvas,
800 x 1200mm (31 1/2 x 47 1/4")

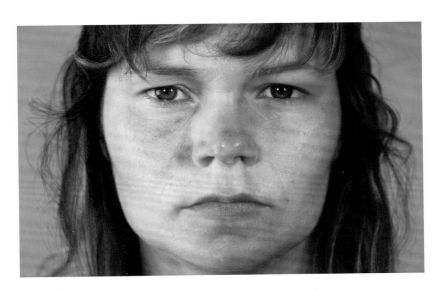

Swallow
Alexandra Gardner

Oil on linen,
400 x 310mm (15³/₄ x 12¹/₄")

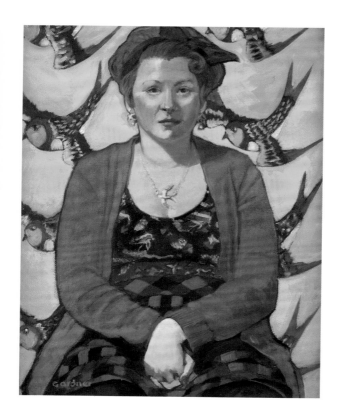

Mary waiting to go roller-skating
Timothy Gatenby

Oil on canvas and wooden box,
700 x 500mm (27$\frac{1}{2}$ x 19$\frac{3}{4}$")
Box: 350 x 370 x 130mm (13$\frac{3}{4}$ x 14$\frac{5}{8}$ x 5$\frac{1}{8}$")

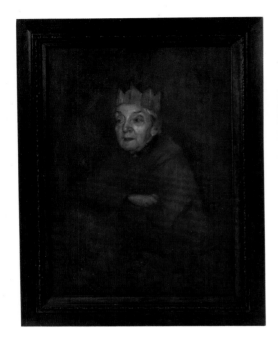

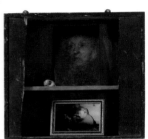

All dressed up for Mam and Dad
Peter Goodfellow

Oil and collage on canvas,
1480 x 1180mm (58$\frac{1}{4}$ x 46$\frac{1}{2}$")

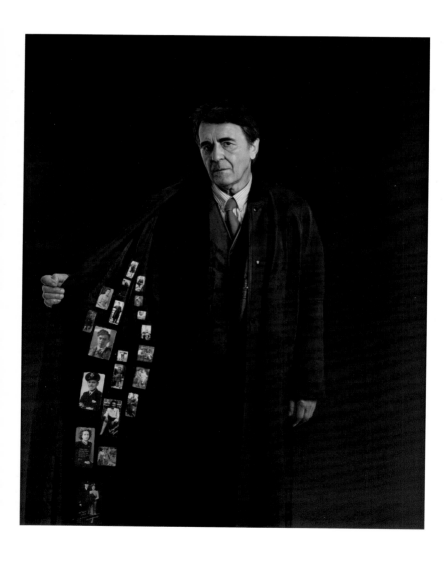

Alex side view
Alex Hanna

Oil on canvas,
550 x 640mm (21$^5/_8$ x 25$^1/_4$")

Paul Ruddock
Eileen Hogan

Oil on board,
255 x 200mm (10 x 7⁷/₈")

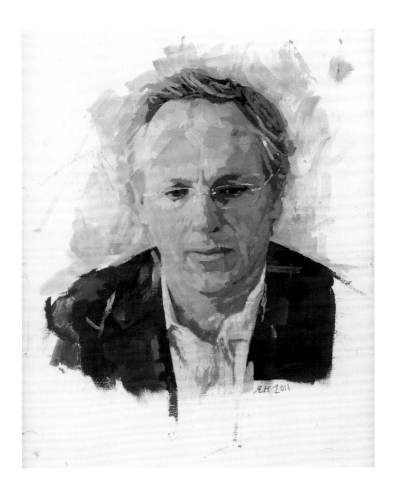

Jane
Leo Holloway

Egg tempera on board,
320 x 380mm (12⁵/₈ x 15")

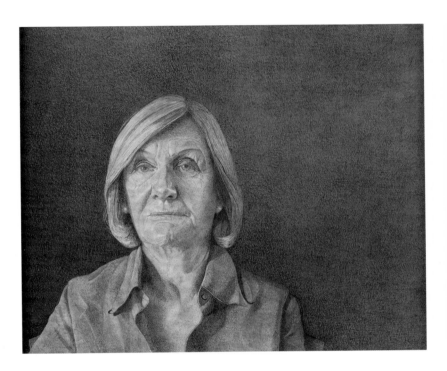

Self-portrait as an Unknown Gentleman
Claire Kerr

Oil on wooden board,
200 x 250mm (7$^{7}/_{8}$ x 9$^{7}/_{8}$")

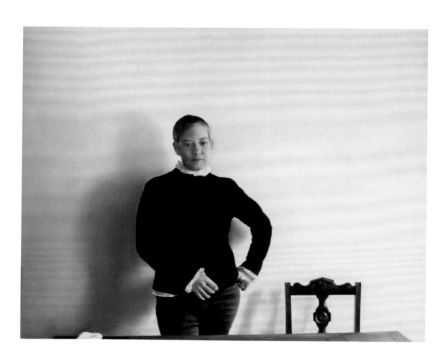

Rosie and Pumpkin
Vanessa Lubach

Oil on canvas,
470 x 395mm (18½ x 15½")

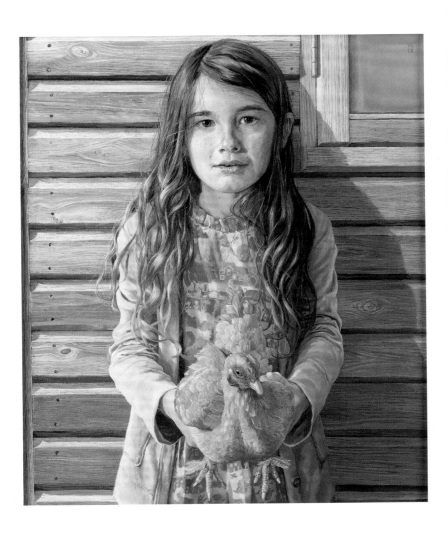

Robin
Lesley McCubbin

Acrylic on wooden board,
250 x 205mm (9⅞ x 8⅛")

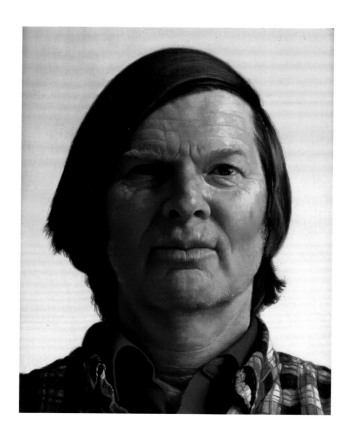

Rasputin always wins
Paul Moyse

Oil on board,
890 x 600mm (35 x 23⅝")

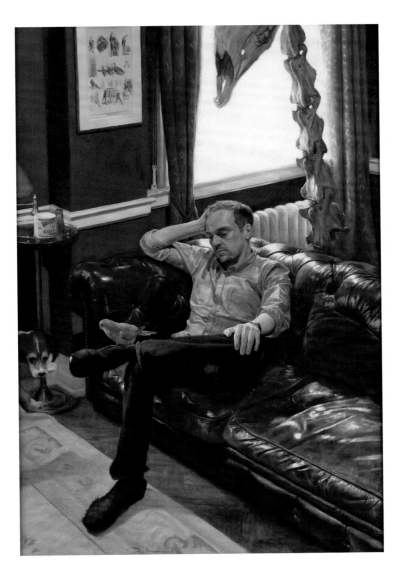

About Time
Toby Mulligan

Oil on canvas,
495 x 400mm (19$\frac{1}{2}$ x 15$\frac{3}{4}$")

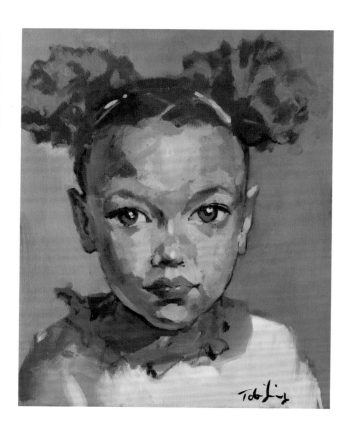

Tessa and the clay heads
Ruth Murray

Oil on canvas,
1700 x 1400mm (66$^{7}/_{8}$ x 55$^{1}/_{8}$")

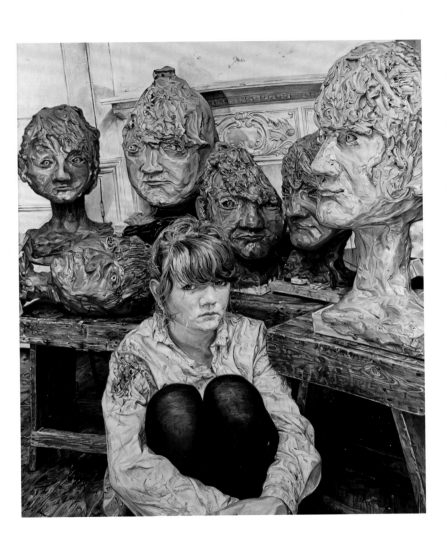

The Twins: Portrait of my wife Jackie
and her sister Christine
Tony Noble

Oil on wooden panel,
1265 x 895mm (49³/₄ x 35¹/₄")

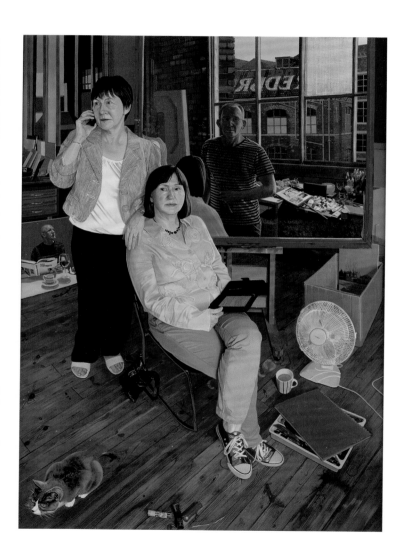

The Skateboarder
Erik Olsen

Oil on canvas,
1220 x 910mm (48 x 35⁷/₈")

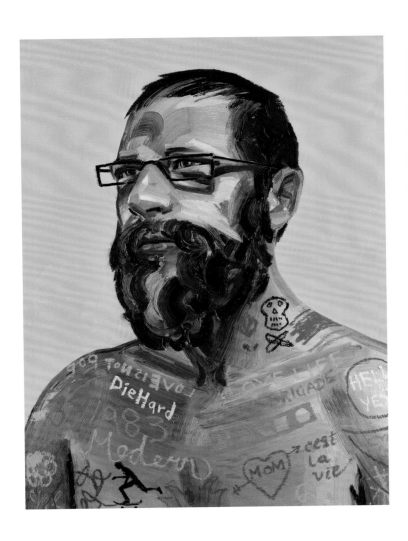

Tim
Anastasia Pollard

Oil on board,
395 x 295mm (15$^1/_2$ x 11$^5/_8$")

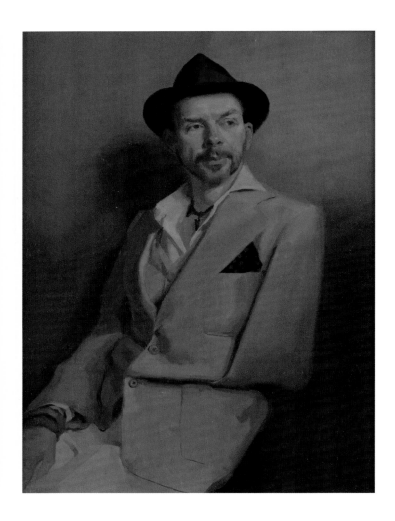

Tom, waiting
Louise Pragnell

Oil on canvas.
385 x 290mm (15$\frac{1}{8}$" x 11$\frac{3}{8}$")

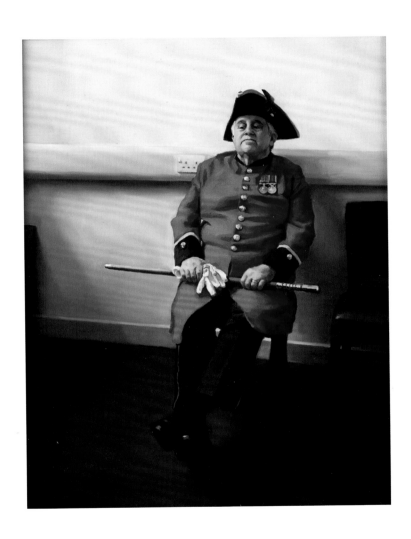

Mr Kitazawa's Noodle Bar, Tokyo
Carl Randall

Oil on canvas,
1615 x 965mm (63⁵/₈ x 38")

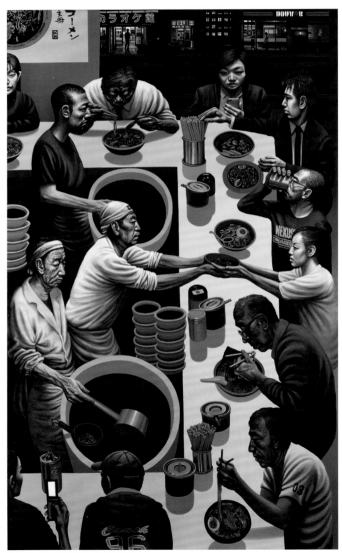

Irish Frank
Ray Richardson

Oil on linen,
910 x 500mm (35$^7/_8$ x 19$^3/_4$")

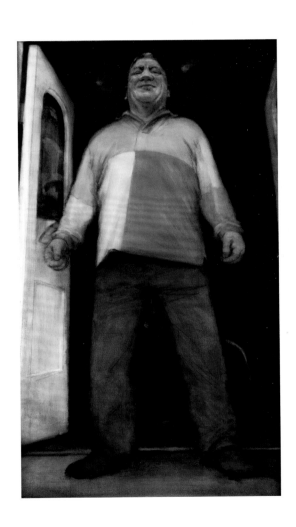

Mr Lascelle Barrow
Aurelio Rodriguez

Oil on canvas,
1850 x 1350mm (72$^{7}/_{8}$ x 53$^{1}/_{8}$")

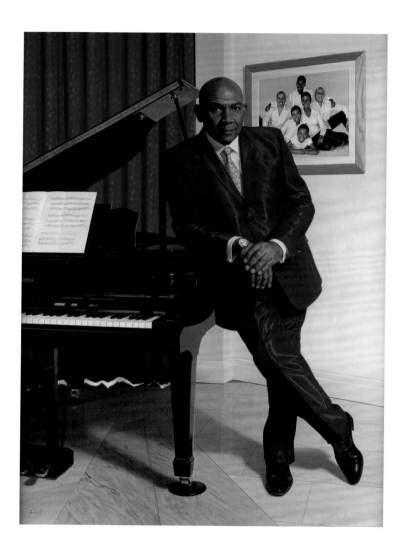

Self-portrait with self-portraits
with reference to *Boy with a
Basket of Fruit* by Caravaggio
Alan Salisbury

Oil on board,
610 x 600mm (24 x 23⁵⁄₈")

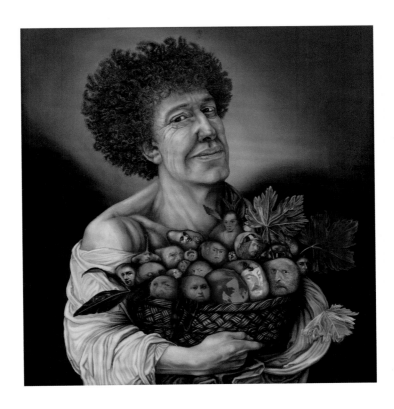

Sam Waley-Cohen and Irilut
James Stewart

Oil on MDF board,
1105 x 1275mm (43$^{1}/_{2}$ x 50$^{1}/_{4}$")

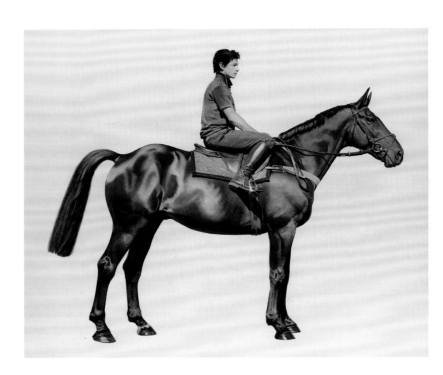

Head Porter
Benjamin Sullivan

Oil on canvas,
345 x 245mm (13⁵/₈ x 9⁵/₈")

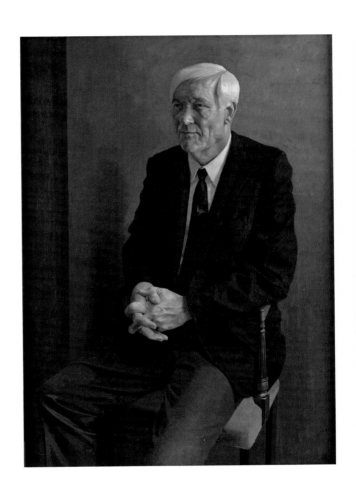

Trying to be something else
Edward Sutcliffe

Oil on canvas,
600 x 450mm (23⁵/₈ x 17³/₄")

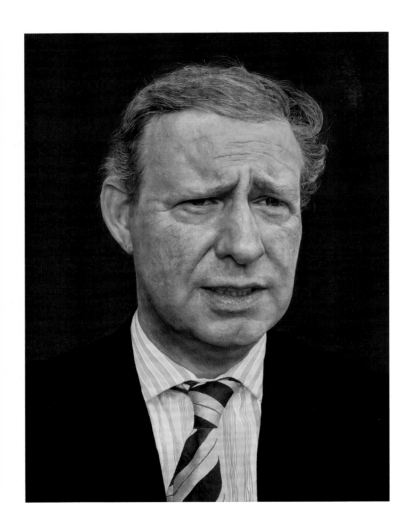

Self-portrait
Roni Taharlev

Oil on canvas mounted on board,
400 x 350mm (15³/₄ x 13³/₄")

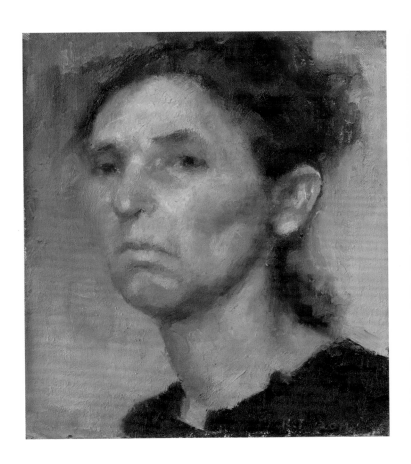

Tony
Elizabeth Thayer

Oil on canvas,
390 x 210mm (15³/₈ x 8¹/₄")

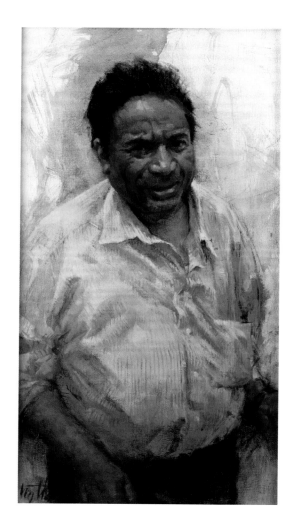

Self-portrait
Jean-Paul Tibbles

Oil on canvas,
765 x 765mm (30$\frac{1}{8}$ x 30$\frac{1}{8}$")

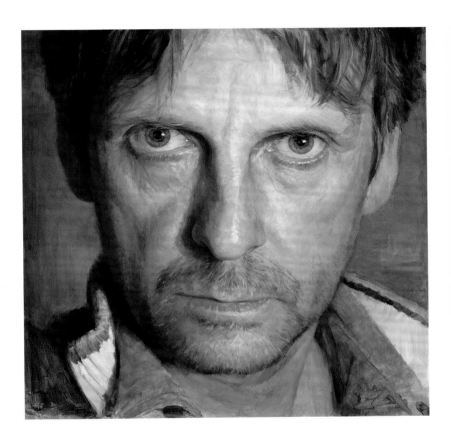

Silent Eyes
Antonios Titakis

Acrylic on canvas,
2200 x 1540mm (86⁵/₈ x 60⁵/₈")

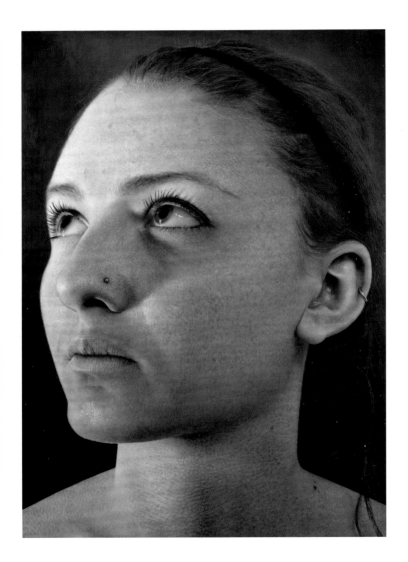

The Importance of Being Glenn
Isabella Watling

Oil on canvas,
1300 x 850mm (51 $^1/_8$ x 33 $^1/_2$")

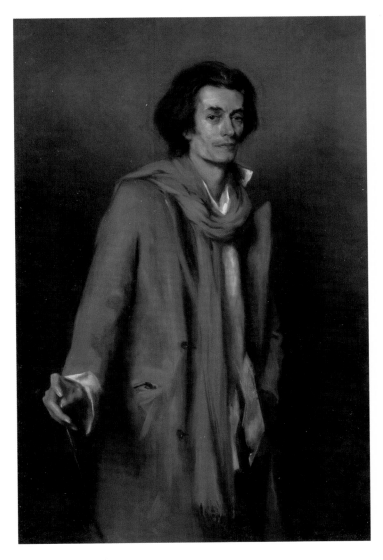

Jack Epstein (Rat of Tobruk)
Peter Wegner

Oil on wooden panel,
215 x 215mm (8$^1/_2$ x 8$^1/_2$")

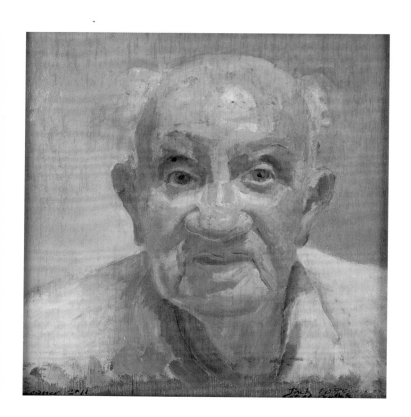

Nick in Tartan Trousers
Emma Wesley

Acrylic on board.
625 x 280mm (24⁵/₈ x 11¹/₄")

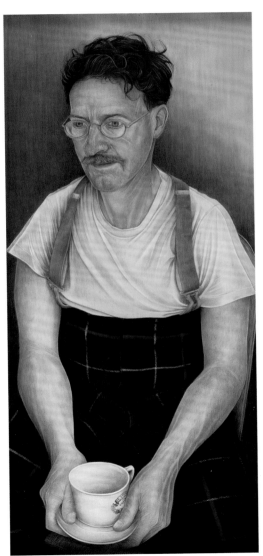

Ian (with prop)
Graeme Wilcox

Oil on canvas,
1850 x 1490mm (72$^{7}/_{8}$ x 58$^{5}/_{8}$")

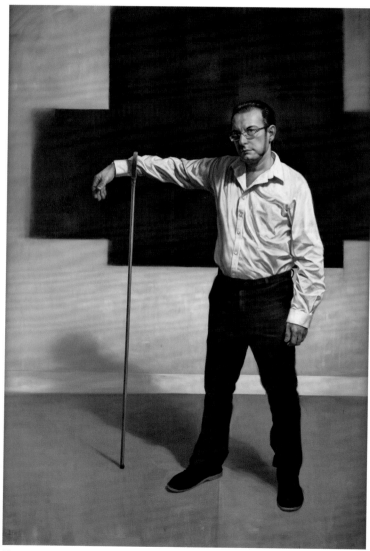

Portrait of Anita Bell in her studio
Agata Wojcieszkiewicz

Acrylic and oil on canvas,
610 x 510mm (24 x 20¹/₈")

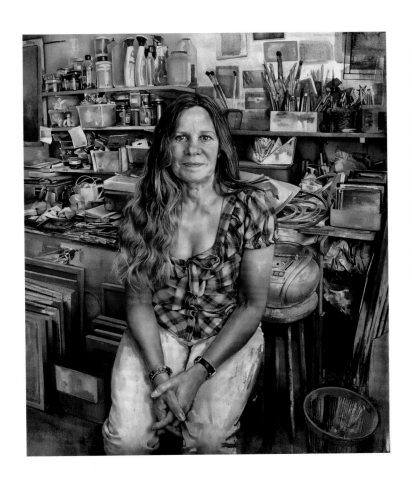

Wes's Dream
Erin Wozniak

Oil on muslin,
210 x 185mm (8^1/$_4$ x 7^1/$_4$")

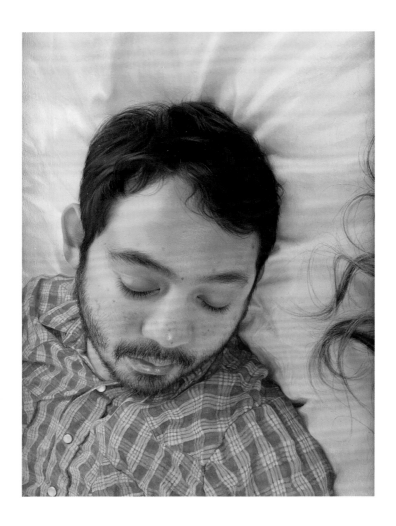

BP TRAVEL AWARD 2011

Each year exhibitors are invited to submit a proposal for the BP Travel Award. The aim of this award is to give an artist the opportunity to experience working in a different environment, in Britain or abroad, on a project related to portraiture. The artist's work is then shown as part of the following year's BP Portrait Award exhibition and tour.

THE JUDGES

Rosie Broadley,
Associate Curator,
National Portrait Gallery

Liz Rideal,
Art Resource Developer,
National Portrait Gallery

Des Violaris,
Director, UK Arts & Culture, BP

The Prizewinner 2011
Jo Fraser, who received £5,000 for her proposal to travel to the Patacancha Valley in Peru to paint local weavers at work.

PAINTING THE QUECHUA WEAVERS

In September 2011 I travelled to the mountains of the Patacancha Valley in Peru to spend four weeks with the people of an impoverished Quechua weaving community. It was the graphic-patterned aesthetic of Andean hand-weaving that first drew me to communities such as this, and led to an appreciation of the allegorical symbolism of their designs and the ritualistic purposes for which they are created: to mark important occasions such as births, deaths and marriages.

A few years ago, while walking through a market street in Tunisia, I became entranced by a small huddle of men and boys who were doubled on their haunches, busily engaged in needlework. Not long after this, I began to nurture an interest in textile production that is practised communally, as part of cultural tradition or through necessity. Looking further into cultural rituals in textile craft, I found that I was responding most strongly to the practices and geometric aesthetic of the traditional textiles of two particular regions: the Andes and the Nordic countries. I was further inspired by the scene of a collective of needlewomen in a painting by Giacomo Ceruti from the 1720s, *Women Working on Pillow Lace*, and was keen to work on a group portrait of women or men working with such skills. At this stage, I was reading a lot about the Peruvian highlands, where weaving is almost exclusively a female occupation and one that consumes their every day. Weaving techniques in this region have been passed down through the generations, from mother to daughter. The women weave on native backstrap looms with yarns spun from the fleeces of their own sheep, llamas and alpacas and, in addition to a considered use of modern embellishments such as plastic sequins, buttons, trim and synthetic dyes, still use ancient, natural dyes. With all this in mind, I clarified my ideas about documenting the weaving traditions of the Andes, and submitted my proposal for the BP Travel Award 2011.

While researching the area of Peru that I was to visit, I stumbled upon Awamaki, a Non-Governmental Organisation that works directly with impoverished weaving communities in the Patacancha Valley. Awamaki work to protect an endangered textile tradition by providing women with access to market. I discussed my project with them and we agreed that I should be introduced to the inhabitants of Patacancha village. Sharing the name of the valley in which it lies, Patacancha sits at an altitude of 12,600 feet. It is the lower of the two communities with which the NGO currently works, and was unaffected by the mudslides that had blocked

access to the higher community for many months following the previous rainy season. It is also one of the larger mountain communities, with around fifty families living and working together. Weeks later, as I trekked higher into the mountains and on through the Lares Valley, I passed many other isolated settlements of perhaps just two or three families. Members of each settlement wear clothing specific to their community, and the communities are distinguishable from one another by nuances in the way the women wear their hair, differing styles in headpieces, particular colours used in clothing or the patterns embroidered on the hems of their skirts.

On the morning of my introduction last September my kit was loaded on to a Combi van at the foot of the mountain and the Director of the NGO joined me for the drive to Patacancha, complacently absorbing violent shocks from the van's suspension as it lurched over crevices and near to edges amid clouds of ochre dust.

The Director and the weavers had discussed the purpose of my stay in a previous meeting and had mutually assigned me to a host family. Shortly after arriving, I was introduced to my host mother, Felicitas Rios Cjuro, her husband Santos, and their three children. Over the next month, my documenting of the community would focus on the weaving practice of the women and, as it happened, it was natural that I spent most of my time with them anyway: the men and boys

farmed the terraces in the mountains, and I saw them only in the mornings, evenings and occasionally at lunch.

My residence hinged on one condition: that my recording of their lives should not be invasive. This suited the way I wanted to approach the work and there was no further discussion. I found it incredibly easy to photograph the women, as they naturally ignored my camera, neither changing their demeanour for the lens nor shying away from it. For a portrait artist, it was fantastic. But frequently, when I sat down to draw or paint, the men and the children would gather behind me, pointing between my subject and her pencilled counterpart – heart-warming, but a little off-putting. So I began to take short lengths of video, too: something I also do with subjects in situations where they are unable to make regular sittings.

Living in such isolation, and without a common tongue, it was easy to philosophise. Quechua lifestyle and practices felt almost unadulterated by urban trends – their culture, descended from the Incas, embraces skills, beliefs and a moral code that is inconsistent with my experience of contemporary Western culture, yet feels so nostalgically familiar to me and compatible with my nature. The women were utterly at one with the spirit of their mountainous surroundings. And in some way, I felt bonded to their way of life by virtue of being female. I noted the fundamentally different roles the males and females have always had in the community. For example, some important maternal attributes of the Quechua woman –

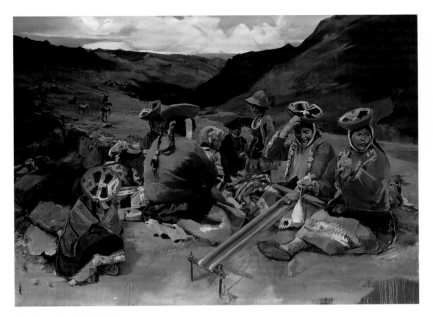

The Weavers by Jo Fraser, 2012
Oil and charcoal on canvas

homemaking, childbearing, textile production and exercising a strong loyalty to community and landscape – are traditionally recognised as universally feminine values, and are ones for which I too, as a member of a deeply invested Scottish family, feel an affinity. Such thoughts were catalysed by our isolation and only propelled by how familiar this remote landscape and these daily rituals felt to me.

My own female relatives demonstrated an innate dexterity for the skills I observed in the Quechua women. When my brothers and I were young, we did not live close enough to our grandmothers for them to hand down to us their skills for crafts –

except for the swift flutter of fingers that was required to produce the most exciting of origami: sweetie-wrapper boats. Instead, I sought the basic techniques of knitting, mending and pattern-reading from my mother. The rest I gleaned from elsewhere, intent on making as many mistakes as necessary to understand each discipline. And it felt imperative to me that I understand these crafts with the same fluency required of spoken language that enables the creative or poetic use of slang. These skills, I feel, are essential to my being female, just as they are to my being an artist, and much of my time in Patacancha was spent drawing parallels between my own needs for artistic creation

and craft and the fact that this is a defining attribute of Quechua culture.

Although largely uninitiated in their way of life, it was not difficult to be inspired by these colourful weavers. With my curiosity for inherited techniques in mind, the idea for a composition came readily to me early in my stay. I wanted to work on something huge, and present these characters sitting in an arc. I wanted to propose that the viewer sit in on their weaving practice, and provide an opportunity to transcend the purely physical aspect of this daily activity and appreciate something of weaver's spirit. At first, I envisaged a village setting, and in the studio I began painting the weavers among thatched awnings, pigs and sun-parched adobe brick structures. Two months in, I took a dark sepia wash over the entire painting and began to paint them into the timeless and epic dynamic of their mountainscape instead.

This project is far from completed. On the contrary, it has provided the space and opportunity for many of my ideas, which I had felt to be separate, to come together, and has therefore highlighted a poignancy. I have gained additional perspectives from the other side of the world that I want to continue to explore in my work.

Jo Fraser

ACKNOWLEDGEMENTS

Congratulations go to all the artists included in the exhibition, and a special acknowledgement for the prizewinners, Aleah Chapin, Ignacio Estudillo and Alan Coulson, and to Jamie Routley, the winner of the prize for a younger painter. My thanks, however, go to all the artists from around the world who decided to enter the 2012 competition.

Thanks go to my fellow judges: Gus Casely-Hayford, Sarah Howgate, Martin Jennings, Nicola Kalinsky and Des Violaris. They were attentive and thoughtful through the two-day selection process and shrewd and decisive in their judgements. I am also grateful to the judges of the BP Travel Award: Sarah Howgate, Liz Rideal and Des Violaris. I would like to offer my thanks to Michael Rosen for his delightful contribution to the catalogue, which links to the intriguing questions of conveying the self in portrait form.

I am very grateful to Kate Tolley for her editorial work, Anne Sørensen for designing the catalogue and also to Michelle Greaves for her overall management of the BP Portrait Award 2012 exhibition. My thanks also go to Austin Barlow, Michael Barrett, Pim Baxter, Stacey Bowles, Nick Budden, Ian Gardner, Eleanor Macnair, Justine McLiskey, Ruth Müller-Wirth, Jude Simmons, Liz Smith, Christopher Tinker, Sarah Tinsley and other colleagues at the National Portrait Gallery for all their hard work in making the project such a continuing success. My thanks go, as in previous years, to The White Wall Company for their contribution to the high-quality management of the selection and judging process.

Sandy Nairne
Director, National Portrait Gallery

INDEX